NICOTEXT

THE HORRIFIC
A – Z

All rights reserved
Without limiting the rights under copyright reserved above, no part of this publication may be reproduced, stored in or introduced into a retrieval system, or transmitted, in any form or by any means (electronic, mechanical, photocopying, recording or otheriwise), without the prior written permission of both the copyright owner and the below publisher of this book, except for the quotation of brief passages in reviews. Any person who does any unauthorized act in relation to this publication may be liable to criminal prosecution and civil claims for damages.

This book is sold subject to the condition that it shall not, by way or trade or otherwise, be lent, resold, hired out, or otherwise circulated without the publisher's prior consent in any form of binding or cover other than that in which it is publised and without a similar condition including this condition being imposed on the subsequent purchaser.

The publisher, authors disclaim any liability that may result from the use of the information contained in this book.

Illustrations: Jimmy Wallin
Text: Lara Allen

Copyright © NICOTEXT 2008 All rights reserved.
NICOTEXT part of Cladd media ltd.
www.nicotext.com
info@nicotext.com

Printed in Hong Kong
ISBN: 978-91-85869-33-6

"TO BORIS KARLOFF, WHEREVER YOU MAY BE."

A

AUDREY (*LITTLE SHOP OF HORRORS*)

Little Shop of Horrors is the 1986 film adaptation of the musical comedy of the same name. The musical was based on the low-budget 1960 black comedy The *Little Shop of Horrors* , directed by Roger Corman. The film is about a florist's nerdy young assistant named Seymour Krelborn (Rick Moranis). The day of a solar eclipse, Seymour discovers a mysterious new plant, which is later revealed to have came from outer space. He names the plant "Audrey II," because of his secret crush on his co-worker Audrey Fulquard (Ellen Greene). Seymour accidentally cuts his finger and discovers that Audrey II has an appetite for human blood. Eventually, the now-huge Audrey II begins to talk to Seymour, demanding more blood than Seymour can give and convinces Seymour to kill people for him to eat.

The film opens with the words: "On the twenty-third day of the month of September, in an early year of a decade not too long before our own, the human race suddenly encountered a deadly threat to its very existence. And this terrifying enemy surfaced, as such enemies often do, in the seemingly most innocent and unlikely of places…".

B

BELA LUGOSI

His native Romanian name is Lugosi Bela. He started his career in Hungary starring in various Shakespearean plays and also served in the army during World War I. Following the collapse of the Hungarian Soviet Republic in 1919, Lugosi went into exile in Germany, emigrating to the U.S. a year later. His iconic starring role in *Dracula* came about following an acclaimed stage performance of *Dracula*, but he was not the first choice for the role.

Lon Chaney was under contract to MGM and was therefore the wiser choice. Because of injuries he received in the war, Lugosi developed an addiction to pain killers. He camouflaged his drug addiction on set by sipping burgundy. At the time of his death, Lugosi was in such poor financial straits that Frank Sinatra quietly paid for his funeral.

It is reported that Peter Lorre looked over at Vincent Price during Lugosi's funeral and asked, "Should we stick a stake in his heart just to be sure?"

Just to be clear, they didn't, so perhaps that bat you see flying above Los Angeles is not as innocent as it appears.

CREATURE FROM THE BLACK LAGOON

When William Alland (the film's producer) was a member of Orson Welles' Mercury Theatre, he heard famed Mexican cinematographer Gabriel Figueroa tell of a legend about a humanoid creature that supposedly lived in South America. That legend became the origin of this film. According to producer William Alland, the idea behind the film was originally thought up by an unnamed Brazilian director whom he met at Orson Welles' house.

The unnamed man spoke of a friend of his who disappeared in the Amazon while attempting to film a documentary about a rumoured population of fish people.

The eponymous creature was played by Ben Chapman on land and Ricou Browning in underwater scenes. It was released in the United States on March 5, 1954.

The film has been immortalized in paleontology circles. When Jenny Clack of the University of Cambridge discovered a fossil amphibian in what was once a fetid swamp, she named it Eucritta melanolimnetes, which is Greek for "the creature from the black lagoon."

DRACULA

Before writing *Dracula*, Bram Stoker spent seven years researching European folklore. His biggest influence was Emily Gerard's 1885 essay "Transylvania Superstitions" and an evening spent talking about Balkan superstitions with Arminius Vambery.

The image of a vampire portrayed as an aristocratic man was created by John Polidori. Polidori spent the summer of 1816 with friends including Frankenstein creator Mary Shelley. Three years later, Polidori's *The Vampyre* was published, with his vampire character of Lord Ruthven being based on fellow guest from that fateful summer, Lord Byron.

The Lyceum Theatre, where Stoker worked between 1878 and 1898 was headed by the tyrannical actor-manager Henry Irving, who was Stoker's real-life inspiration for Dracula. Stoker modelled Dracula's dramatic aristocratic mannerisms on Irving's idiosyncrases.

E

THE EXORCIST

Like *The Amityville Horror*, *The Exorcist* is supposedly based on "real" events. Author William Peter Blatty based the novel on newspaper reports of an exorcism. A priest claimed to have exorcised a demon from a thirteen-year-old boy named Robbie. The ordeal reportedly lasted a little more than six weeks, ending on April 19, 1949.

Blatty was actually collecting unemployment benefits when he began to write the novel. He won $100,000 on the television show *You Bet Your Life*, telling Groucho Marx he planned to write a novel with the money. The Exorcist was the result. While the book was wildly popular, it was the movie adaptation with Linda Blair's creepy swirling head, that ingratiated the story into popular culture.

Even Christian evangelist Billy Graham was affected by it, claiming an actual, live demon was living within the movie. He may be right; in the scene in the language lab, a white banner is visible with the letters TASUKETE written in red. TASUKETE means "help me" in Japanese.

F

FRANKENSTEIN

Mary Wollstonecraft Goodwin was 19 years old when she conceived what would later become the infamous novel *Frankenstein*. In the summer of 1816, the young writer (along with her lover Percy Bysshe Shelly) paid a visit to Lord Byron in Switzerland. As the weather during their stay forbid any outdoor activites, the group stayed inside, talking, reading and entertaining themselves.

After reading *Fantasmagoriana* – an anthology of German ghost stories – they challenged one another to each compose a story of their own. The winner would be whoever wrote the most terrifying tale. Mary based her story on the memory of a nightmare in which she saw "the pale student of unhallowed arts kneeling beside the thing he had put together." This was the birth of Frankenstein.

Contrary to popular belief, the creature in fact doesn't have a name; that's part of Frankenstein's (the scientist's) rejection of his creation. Instead, it's referred to as "monster", "creature", "demon", "fiend" and "wretch" which would make anyone angry enough to attack a village, even if they were all carrying torches.

G

GODZILLA

The world's most famous kaiju (Japanese monster) first appeared in the movie *Godzilla* in 1954.

The name is a combination of two words: gorira (gorilla) and kujira (whale). This explains Godzilla's aquatic origin as well as his bulk and power. In the movie, the monster was portrayed by Haruo Nakajima in a very uncomfortable rubber suit. During filming, it was common for an entire cup of Haruo Nakajima's sweat to be drained from the Gojira suit. Whether or not he drank it to replenish himself is unknown.

HANNIBAL LECTER

In 1992, author Thomas Harris attended the ongoing trials of Pietro Pacciani, the man suspected of being the Monster of Florence – a notorious and brutal serial killer. Parts of the killer's modus operandi were used as reference for the character Hannibal Lecter, who has appeared in many of Harris's novels. Harris' most famous novel is arguably *The Silence of the Lambs*, which was later turned into a wildy successful movie starring Anthony Hopkins as Lecter.

Hopkins claimed that he drew inspiration for Lecter's voice from HAL-9000, the villainous computer from Stanley Kubrick's *2001: A Space Odyssey*. Hopkins' vocals undoubtably add an extra level of creepiness to his portrayal of Lecter; the actor himself has described his sound as "a combination of Truman Capote and Katherine Hepburn."

The character of Hanibal Lecter was a methodical serial killer who hunted, murdered, cannibalized and often skinned his victims. In 2007, Lecter's line "I ate his liver with fava beans and a big chianti" was voted the 74th greatest movie line in history.

INVASION OF THE BODY SNATCHERS

First released in 1956, *Invasion of the Body Snatchers* has been hailed as a thinly veiled metaphor for various political viewpoints. The two main interpretations encompass the perceived loss of personal autonomy in the Soviet Union and alternatively, an indictment of McCarthyist paranoia about Communism during the early stages of the Cold War. Though most film critics are certain of these political themes, lead actor Kevin McCarthy said in an interview (included on the 1998 DVD release) that he felt no political allegory was intended at all.

Jack Finney, author of the original novel, also claims that no specific political allegory was intended. In his autobiography, producer Walter Mirisch writes: "People began to read meanings into pictures that were never intended. *The Invasion of the Body Snatchers* is an example of that. I remember reading a magazine article arguing that the picture was intended as an allegory about the communist infiltration of America. From personal knowledge, neither Walter Wanger nor Don Siegel, who directed it, nor Dan Mainwaring, who wrote the script nor the original author Jack Finney, nor myself saw it as anything other than a thriller, pure and simple."

The trouble is, without any hidden meanings, the film just comes across as dumb — so the rumors persist.

J

JASON (FRIDAY THE 13TH)

The full name of the brutal killer in the popular *Friday the 13th* films is Jason Voorhees. His father's name was Elias Voorhees and Jason's mother was only sixteen when she gave birth to him. One of the most famous things about Jason is not his appearance, but the music that announces it. Composer Harry Manfredini has said that contrary to popular belief, "chi chi chi, ha ha ha" is "ki ki ki, ma ma ma". It is meant to resemble Jason saying "kill kill kill, mom mom mom".

When Manfredini first began working on the score, he and the filmmakers decided to only play the music alongside the killer, so it wouldn't "manipulate the audience" into thinking the killer was present when he wasn't. He also said when something big was going to happen, the music would begin, but then cut off suddenly so the audience would relax a bit, setting them up for an even bigger scare.

When Manfredini tried the same tactic in his personal life, his wife had him committed for extreme sadism.

K

KRUEGER, FREDDY

The famous undead serial killer in *the Nightmare on Elm Street* films was originally a child molester as opposed to child killer. Krueger was changed to a child killer so the public wouldn't accuse the movie makers of trying to exploit a series of child molestations occurring throughout California at the time of the movie's release.

Despite his believable portrayal of Krueger, actor Robert Englund has a reputaion as a nice guy. During the famous "blood geyser" scene, Englund rescued actress Heather Langenkamp who plays the roll of Nancy Thompson. The sequence was shot by turning the entire room upside-down on a gyro set and sending the blood down through the bed. The two actors were watching the filming as the room itself began to turn, but it was turned in the wrong direction and the blood began to surge prematurely. The fake blood gushed onto exposed wires, creating a dangerous hazard. Fortunately, Englund pulled Langencamp away to safety before anything serious happened, and the sequence was somehow salvaged. This incident is described by Englund in a booklet within the *Friday the 13th* commemorative boxed set.

LEATHERFACE (TEXAS CHAIN SAW MASSACRE)

In the original *Texas Chain Saw Massacre* film, the creepy Leatherface is never seen without one of his human-flesh masks on. The reason he wore a mask, according to the writers, was that the mask determined his personality.

So, when Leatherface donned is wearing the "Grandmother Mask" along with an apron and wooden spoon – he wanted to be domestic, helpful in the kitchen. At dinner he wore a different face – the "Pretty Woman". Even with the help of make-up, this mask unfortunately didn't live up to its name.

M

MICHAEL MEYERS (*HALLOWEEN*)

The "star" of *Halloween* was a mere six years old when he killed his first victim, his seventeen year-old sister. In the original movie, he was referred to as "The Shape" and not his real name, Michael Meyers.

The second movie reveals Laurie Strode, (who Michael Myers stalked through the entire first movie), is actually his younger sister. It's obviously rather dangerous to be a female sibling of Michael Meyers; he has "issues".

N

NOSFERATU

The 1922 German expressionist film that inspired rumors of real vampires and many creepy movies to come was a kind of unauthorized adaptation of the ultimate vampire tale, *Dracula*. Names and details were slightly altered as the studio couldn't obtain rights to the novel.

The movie is so creepy and terrifying, it was banned in Sweden until 1972. The persistent rumors that its star, Max Schreck was a member of the undead were based partly on the 2000 movie Shadow of the Vampire which stars Willem Dafoe, and partly on Schreck himself, who was deemed so ugly the director of Nosferatu asked for no makeup, only false teeth and pointy ears. Also, the character of Nosferatu is never seen blinking – a subtle but effective way of upping the horror.

O

THE OMEN

It's amazing anyone would name their child "Damien" after seeing this movie. Somehow, the movie managed to make its audience terrified of a small child...the son of the Antichrist and a jackal. In the movie, without doing much other than staring and smiling creepily, Damien manages to kill off his nanny, his unborn sibling, his brother, his parents and several priests. As with most horror movies, a rumor about a "curse" surrounded the making of the film, particularly among the filmmakers and crew. Gregory Peck (star of the original film) had his plane struck by lightning, as did the scriptwriter David Seltzer in a seperate accident. The original plane Peck had chartered, which he canceled his reservation for, crashed killing all on board. The rottweilers used in the film became violent, attacking their trainers. On the first day of shooting, the principal members of the crew were involved in a head-on car crash.

But the best 'Omen' may be the casting of the lead role. Harvey Stephens, the child cast as Damien, was chosen for this role because he attacked director Richard Donner during auditions. Donner had asked all the little boys to "come at him" as if they were attacking Katherine Thorn during the church wedding scene. Stephens screamed and clawed at Donner's face, kicking him in the groin during his act. Donner whipped the kid off him, ordered his blond hair dyed black and cast him as Damien.

In the 2006 remake, the same part was played by Seamus Davey Fitzpatrick, another creapy little boy.

PSYCHO

Psycho is the best-known film by the master of suspense, Alfred Hitchcock. The film actually began its life as a book inspired by the life of serial killer Ed Gein. The movie is a genre defining film, named one of the most effective horror movies of all time. Almost every scene has been parodied or copied at some point in the forty-seven years since its release, especially the infamous "shower scene". Arguably the most famous scene in cinematic history, the shower scene has been analyzed to death and has fueled countless myths: (in fact, the knife penetrates three times in quick succession; it's done for subliminal effect.)

Alfred Hitchcock and Janet Leigh are a little more insightful when it comes to the true meaning of the shower scene:

"Marion had decided to go back to Phoenix, come clean, and take the consequence, so when she stepped into the bathtub it was as if she were stepping into the baptismal waters. The spray beating down on her was purifying the corruption from her mind, purging the evil from her soul. She was like a virgin again, tranquil, at peace."

QUEEN OF THE DAMNED

Anne Rice's third novel in the *Vampire Chronicles* follows *Interview with a Vampire* (by far her most famous work) and *The Vampire Lestat*. The Queen in the title is the mother of all vampires. In 2002 the lead roll went to R&B singer Aaliyah and the film received terrible reviews. The story revolves around the vampire Lestat, a famous rock star. Lestat attracts the attention of the Queen, who prefers her vampires to remain hidden.

Despite her initial worries, Anne Rice was eventually convinced to allow her name to be attached to the movie. Still, fans hated it, mainly due to the major fundamental differences between the book and the movie, including but not limited to:

- In the movie most vampires can fly, but in the book it is only the oldest who can do so. In the book, Lestat can't fly until he drinks the blood of the Queen.

- The movie shows the Queen and Lestat are out during the day, able to go into the sun without being burned. In the book, this is not the case; no vampire can be exposed to sunlight without some injury. The younger ones will be killed; the elder, burned.

- Most importantly, there is no discussion about the origin of vampires in the film. This is a central plot point in the book and plays a large roll in the allure of the story.

THE RAVEN

"Once upon a midnight dreary, while I pondered, weak and weary..." so begins one of the most famous, poems in the English language. Edgar Allan Poe's raven, who slowly drives the narrator insane with his one-word answers, is never clearly described as being aware of what he's saying. Still, the narrator asks impossible questions that the bird, in truth, cannot answer even if he were capable of speech. Poe is arguably the first American horror writer. This particular poem had an enormous impact on audiences with its intense imagery and portrayal of insanity. Its popularity continues today; the Raven has been parodied and referenced in countless works of art, film and literature. In the cartoon *Donald Duck*, Huey, Dewey and Louie develop a friendship with a raven who can only say 'nevermore', Jack Nicholson's character The Joker also quotes the poem in the film *Batman* (1989). *The Simpsons* also incorporate the Raven into their first Treehouse of Horror episode, in which Lisa reads the story to Bart and Maggie.

S

SCREAM

The 1996 film revitalized the horror genre (not to mention Drew Barrymore's career) by taking a tongue-in-cheek approach to the "slasher" film. The title comes from the killer's trademark mask, reminiscent of Edvard Munch's famous painting. The film's signature, other than the mask, are the "rules" outlined in each movie:

In *Scream*, those rules (as described by Randy) are:

- You may not survive the movie if you have sex.
- You may not survive the movie if you drink or do drugs.
- You may not survive the movie if you say "I'll be right back" or "who's there?"

Rules were also given in the trailer:

- Don't answer the phone
- Don't open the door
- Don't try to hide
- But most all of all...don't scream

T

THE THING (1982)

This 1982 horror/sci-fi film is essentially a remake of a 1951 movie called *The Thing From Another World*, but is more faithful to the original work: a story by John Campbell Jr. The film is about a shape-shifting alien that is revived after being frozen in ice. The alien infiltrates a scientific research station in the Antarctic and kills a Norwegian research team. A nearby American research team investigates the incident and in turn are attacked by the alien.

In the beginning of the film, the "Norwegian" with the rifle is Kurt Russell's (then) brother-in-law, Larry J. Franco. According to director John Carpenter, Franco is not speaking Norwegian but making up the dialogue on the spot... "Schmergsdorf" as Carpenter calls it. The subtitles, however, give the impression he is speaking Norwegian. The words spoken are actually vaguely understandable for Norwegians: "Se til helvete og kom dere vekk. Det er ikke en bikkje, det er en slags ting! Det imiterer en bikkje, det er ikke virkelig! KOM DERE VEKK IDIOTER!!" Roughly translated: "Get the hell outta there. That's not a dog, it's some sort of thing! It's imitating a dog, it isn't real! GET AWAY YOU IDIOTS!!"

U

UNDEAD

No horror buff should be ignorant of the concept of the "undead". The term "undead" is a general name for creatures believed to be dead but behaving as if they are alive. Undead may be spiritual, such as ghosts, or corporeal, such as vampires and zombies. Undead are featured in the legends of most cultures and in many works of fantasy and horror fiction. In fact, Bram Stoker considered the term as the original title for *Dracula*. His use of the word to describe his vampire is considered responsible for the popularity of the term now. Of course, the word "undead" does appear in English before Stoker's usage but with the more literal sense of "alive" or "not dead," for which citations can be found in the Oxford English Dictionary.

Stoker's undead were all vampires, but Mary Shelley created a whole new species with her creation of *Frankenstein*. Zombies have existed in myth and folklore for centuries. Most undead animation rituals involve the reanimation of a corpse as with zombies, skeletons and ghouls. Regarding ghosts, the spirit lives on after death forming an intangible physical body that often mirrors the one the spirit had in life. Rituals appeasing the uneasy spirits of the dead were a feature of ancient Greek religion (keres) and ancient Roman religion (lemures).

V

VELOCIRAPTOR (*JURASSIC PARK*)

The Velociraptor (commonly shortened to 'raptor') is one of the dinosaur genera most familiar to the general public due to its prominent role in the *Jurassic Park* motion picture series. The velociraptor represented in the films was anatomically inaccurate; it was portrayed without feathers and much larger than it was in reality.

The "raptors" portrayed in *Jurassic Park* were modeled after a larger relative, Deinonychus, which Gregory Paul at the time called Velociraptor Antirrhopus. It was a bipedal feathered carnivore with a long, stiffened tail and an enlarged sickle-shaped claw on each hindfoot, which was used to kill its prey.

WEREWOLF

Werewolves have been around for as long as man has recorded history. The ancient Greeks may have been the first to associate them with a full moon, – an idea later picked up by medieval writers. Many authors/theorists have speculated the werewolf myth exists to provide an explanation for serial killings. A fungus called 'ergot' has also been blamed for werewolf fantasies. Ergot is a foodborne illness that results in hallucinations and convulsions (LSD is derived from ergot). The theory suggests that ergot poisoning is the cause of both an individual's belief they are a werewolf and an entire town's belief in the existence of said werewolf. This theory, however, is not widely accepted. Other researchers have tried to use conditions like rabies, hypertrichosis (excessive hair growth over the entire body), or porphyria (an enzyme disorder with symptoms including hallucinations and paranoia) to explain werewolves. Congenital erythropoietic porphyria has clinical features which include hairy hands and face, poorly healing skin, pink urine, reddish colour to the teeth and photosensitivity, which leads sufferers to only go out at night.

A more likely explanation for werewolves is a rare mental disorder called clinical lycanthropy. Sufferers of clinical lycanthropy have a delusional belief that he or she is, or has transformed into, another animal (not necessarily a wolf).

X

XENOMORPH (*ALIEN*)

Xenomorph is the technical name of the terrifying species of alien that tortured poor Ripley in the *Alien* movie series. Unlike a lot of other alien species appearing in movies, Xenomorphs aren't an intelligent lifeform; they are solely predatory. They have no higher goals than propagation of their species. Their size and power, coupled with this sole focus, is what makes Xenomorphs so terrifying.

One of the defining characteristics of this particular species is laying of eggs in human stomachs; the alien babies burst out of their host's stomach after the appropriate incubation period. This concept was inspired by the breeding habits of spider wasps, which lay their eggs on the abdomens of spiders. When the wasp larva hatches, it feeds on the edible parts of the still-live spider, then spins a cacoon and pupates.

Y

SADAKO YAMAMURA (*RING*)

Ring (Ringu) is a Japanese horror film from director Hideo Nakata, adapted from the novel of the same name by Koji Suzuki, which draws from the Japanese folk tale "Banch Sarayashiki". The film stars Nanako Matsushima, Hiroyuki Sanada, and Rikiya Otaka as members of a divorced family, each cursed by a videotape. The film was later remade in Korea as *The Ring Virus* (1999), and in the United States as *The Ring* (2002). The antagonist of the popular *Ring* series of movies is portrayed in the original novel as suffering from testicular feminization syndrome. In other words, she was anatomically male.

If you play the video of the American version of the Ring from the very beginning, you actually see the "cursed" video. After the segment ends, you hear a phone ringing twice before the previews begin. When the movie has ended, you see additional scenes that help explain the mystery of the cursed video.

The makers are not responsible for what happens next.

Z

ZODIAC

Zodiac is a film from 2005 based on true events involving the Zodiac killer – a serial killer who operated around the San Francisco Bay area in the 1960s who has never been identified or captured. Director, Alexander Buckley and his brother Kelly, the screenwriter for the film, grew up in the San Francisco Bay area and were therefore particularly drawn to the story.
In an interview with Rotten Tomatoes Alexander said: "I lived in the Bay Area where he was somewhat of a local legend. Every town has a 'boogie man' and he was ours. The stories of the murders kept us kids awake at night."

The Zodiac killer was dubbed so due to a series of taunting letters he sent to the San Francisco Chronicle. His letters included four cryptograms (or ciphers), three of which have yet to be solved.

The last confirmed Zodiac correspondence is dated May 8, 1974 and was a complaint about the movie *Badlands*. The San Francisco police department currently lists the case as "inactive"...further fueling the numerous theories and myths surrounding the mysterious killer that may still walk among us.